W9-DIN-581

The Art of Nature Inc.

the Four Seasons

PHOTOGRAPHY BY BRUCE HEINEMANN

selected poems of Emily Dickinson

Edna St. Vincent Millay

William Cullen Bryant

Robert Frost

performance of Antonio Vivaldi's Four Seasons by The Cambridge Chamber Orchestra

Rolf Smedvig, conductor

Bruce Heinemann's photography is represented by PhotoDisc, Inc.
Call (206) 441-9355 or see his imagery online at www.photodisc.com

For a complete listing of all of Bruce Heinemann titles and Art of
Nature products, call for a free catalog (800) 786-6359.

The Four Seasons
ISBN 0-930861-45-0

The Art of Nature Inc.
1000 Lenora Street, Suite 514
Seattle, WA 98121

(800)786-6359
Fax (206)748-0180

Reprinted by permission of the publishers and the Trustees of Amherst
College from THE POEMS OF EMILY DICKINSON, Thomas H. Johnson, ed.,
Cambridge, Mass.: The Belknap Press of Harvard University Press,
Copyright © 1951, 1955, 1979, 1983 by the President and Fellows of
Harvard College.

"Afternoon on a Hill," Copyright 1917, 1945 by Edna St. Vincent Millay.
From COLLECTED POEMS, Harper Collins.

From: THE POETRY OF ROBERT FROST, edited by Edward Connery Lathem,
Copyright 1951 by Robert Frost, Copyright 1923, © 1969 by Henry Holt and
Company, © 1997 by Edward Connery Lathem. Reprinted by permission of
Henry Holt and Company, Inc.

Design by Ted Mader Associates, Inc. Seattle, WA and Oakland, CA.

Printed in Hong Kong by Palace Press, San Francisco, CA.

It is difficult to imagine a theme or experience of living more powerful, relevant, or as fundamental to life on earth as the four seasons. Indeed, as the earth journeys around the sun, we too, like the flora and fauna with whom we share this planet, ebb and flow to the rhythm of its terrestrial cycles. Imbedded deeply in our psyches are the sensory experiences of the seasons we gather as we move through our lives: the sweet, earthy fragrance of fresh cut hay; the piercing sting of cold air drawn into our lungs; the brilliance of an October hillside; the burst of sweetness from the bite of an apple picked fresh from the tree; the deafening roar of a snow-melt swollen river. Rooted as well, are the metaphorical notions of birth, death, renewal, and the continuum of life.

If there exists a subtle irony in the seasons, perhaps it is that our experience of them is as common and universal as they are personally unique. As a photographer, I am most interested and attuned to the progression of the seasons. In particular, I seek the beautiful but subtle changes of color, light, and form that occur minute to minute, day by day, that are often unseen by the potential observer, one too busy or uninterested in seeing.

In contemplating Vivaldi's inspiration for this work, I've often wondered what he might have written had he wandered through a misty old growth forest of the Pacific Northwest or gazed upon the soaring redrock monoliths of Monument Valley. Perhaps nothing different, really. For, as I look through my lens at these remarkable landscapes and hear his music, the power, expression, and universal nature of these works manifest themselves for me as eloquently in the lush, damp green forest or the vast expanse of earthtones and light in the desert Southwest as they do in the Italian countryside.

My long-standing interest in the synergistic possibilities of visual and musical expression made this project inevitable. I have the good fortune to bring to this project a truly outstanding performance of Vivaldi's Four Seasons by the finest players of The Boston Symphony Orchestra, conducted and directed by twice Grammy-nominated trumpet virtuoso, Rolf Smedvig, my long time friend and music mentor. I have also chosen to include in this book and music CD, four of America's greatest poets, Emily Dickinson, Edna St. Vincent Millay, William Cullen Bryant, and Robert Frost, whose poems give voice to those common experiences we know as the seasons.

Peering out the motel window the next morning, the fog once again lay heavy in the valley. With my photo trip nearing its end and a pass through Utah still in my plans, I thought it best to move on. Consumed with disappointment, I loaded the car. Suddenly I stopped, looked up, and thought, this weather surely must break for me. Without another moment of consideration, I was headed back to the park. Barely inside the park, a beam of sunlight, burning a hole through thick clouds, lit up a row of aspens in the distance. As the minutes passed, the clouds and fog began to lift ever so gradually, revealing but glimpses of the vast river valley and towering peaks beyond, as if only to tease me. At last I prevailed, as inevitably they melted away in the heat of the sun, exposing the vast expanse of the Tetons in their full glory.

Heading out of the park late in the day, I made one last stop to shoot the sunset from an oft-photographed overlook. The sun was hidden by a few lingering clouds as it went down over Mt. Moran. Within minutes, however, the sky began to pulsate, radiating intense hues of magenta, orange, and yellow, that seemed to set the entire valley on fire. The glowing light, reflecting from the snow, illuminated the jagged faces of the peaks silhouetted by the sunset. As the fire turned to embers, I contentedly packed my gear to leave. Looking up, I smiled, as the first star sparkled silently in the night sky.

Bruce Heinemann

Antonio Vivaldi and The Four Seasons

Industrial pollutants gnaw at her Renaissance facades, while the waves of the Adriatic creep ever closer to the foundations of the great city. This is Venice, the tarnished "Jewel of the Adriatic". Once one of the leading maritime powers and a center for the arts, Venice is slowly but inexorably slipping into history but, in her glory, she was one of a handful of places that could truly be called great. Of all the arts that flourished in that city during her stretch of greatness, it was music above all that set Venice aside from all the rest. The great cathedral of San Marco acted as a beacon for some of the greatest talents in history, giving the world the Gabrielis and, through them, Schutz. Monteverdi graced the world with his finest creations there. In the 18th century, the tradition lived on in the person of "red priest", Antonio Vivaldi.

Among the many attractions offered by the city was its music, proclaiming that "among the best to play the violin are Gian-Battista Vivaldi and his priest-son, Antonio." Antonio apparently inherited his father's musical talents and became one of the continent's greatest virtuosi. Early in life he was ordained to the priesthood, but his career was a curious one. He was afflicted with a strange ailment that prevented his saying the Mass and he was eventually allowed to forego that most essential clerical duty. That dispensation gave him the opportunity to devote his full energies to his post at the Pio Ospedale della Pieta. One of several such homes for girls in Venice, the Ospedale's sole purpose was to provide a splendid musical education for its charges. That it did, and the concerts given by the various homes became famous throughout Europe. Vivaldi stayed there for 40 years, eventually rising to the post of Maestro de concerti (concert master).

The concerto form was a relatively recent creation and it gained rapid favor in Italy. They were of two primary types: one for a solo instrument and orchestra, and one for two bodies of instruments playing against each other, called the concerto grosso. Vivaldi wrote a great deal of music for both, but he tended to favor the solo concerto due to his own tremendous technique with the violin.

Of the more than four hundred examples of those left to us, certainly the most popular has been the group known as Le Quattro Stagioni (The Four Seasons). These four concertos are actually part of a larger group known as the Opus 8. Twelve concertos are included in all. The full title for the Opus 8 is Il cimento dell'armonico e dell'inventione (The Trial of Harmony and Invention). Program and absolute music abide together in this Opus 8, as do examples of concerto grossos and solo concertos. These juxtapositions of differing styles and the resulting musical richness are some of the reasons behind the enduring popularity of the Four Seasons.

The Opus 8 is scored for strings and harpsichord continuo alone. The concertos are divided into the standard three movements: fast, slow, and fast. The first quartet of concerto from this Opus 8 are The Four Seasons and they are one of the earliest, and most splendid, examples of programmatic writing. Each concerto describes, through the music and the instrumental scoring only, "scenes" from the seasons of the year.

Among the intriguing aspects of the music is the use of poetry to help the listener understand the music. Each section has a sonnet heading it (probably written by Vivaldi himself). Next to individual lines, the composer added the letters "A", "B", "C", etc. These corresponded to specific musical passages in the score, also marked with "A", "B", "C", and so on. In that unique way, everyone knew exactly what Vivaldi was doing.

Michael C. Conley

sping

A light exists in spring
Not present on the year
At any other period.
When March is scarcely here

A color stands abroad
On solitary hills
That science cannot overtake,
But human nature feels.

It waits upon the lawn;
It shows the furthest tree
Upon the furthest slope we know;
It almost speaks to me.

Then, as horizons step,
Or noons report away,
Without the formula of sound,
It passes, and we stay:

A quality of loss
Affecting our content,
As trade had suddenly encroached
Upon a sacrament.

EMILY DICKINSON

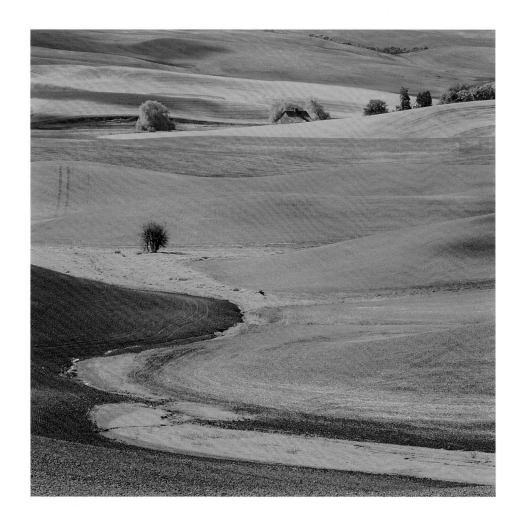

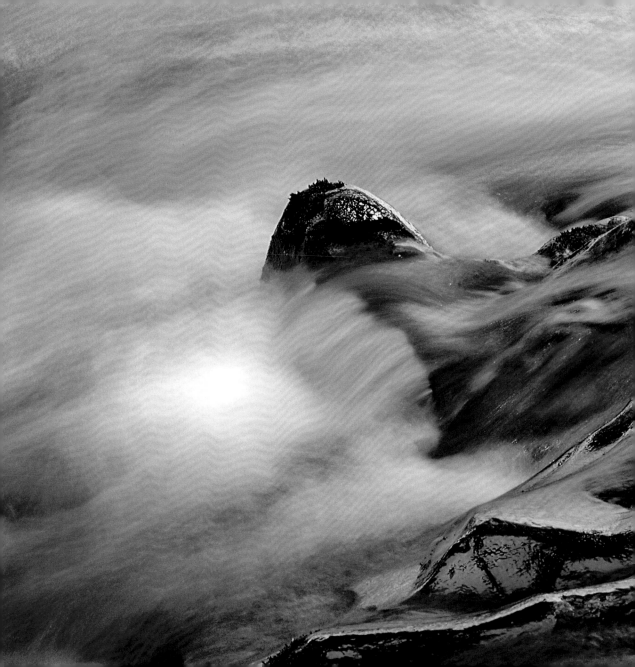

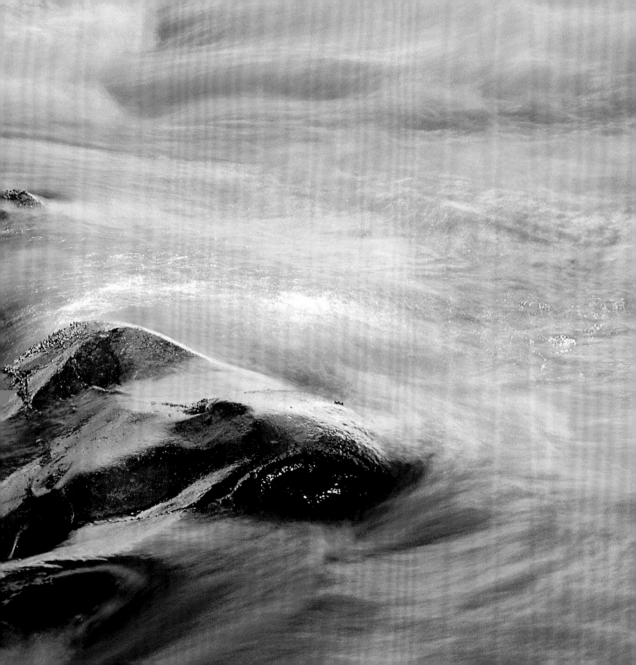

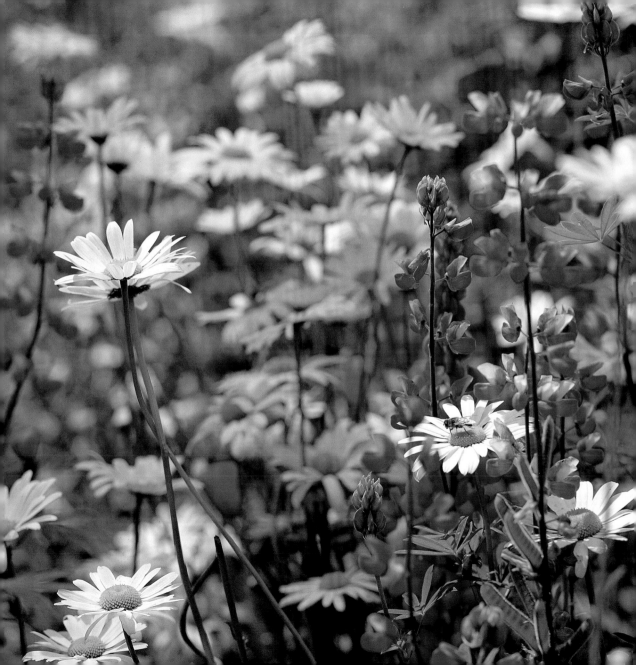

contents

2	introduction
5	notes on Antonio Vivaldi and *The Four Seasons*
8	spring
20	summer
32	autumn
44	winter
56	photographic plates
58	soundtrack notes

introduction

Stepping from my car, I headed towards the gas cashier at the minimart, squinting upwards to see if the stars were still out. My photographic journey through southern Idaho that day had been blessed with an extraordinary combination of sunshine, snowfall, and fog. In two more hours I would arrive at Grand Teton National Park, a magnificent and stunning natural creation that I had longed to photograph for many years. In my mind I held an image of a brilliant dawn painting the crimson hue of its first rays across the craggy face of the Tetons.

Leaving the parking lot of the motel the next morning the headlights of my rental car reached scarcely more than a few feet through the dense fog. Sipping my coffee as I drove to the entrance of the park, I let go of the sunrise image, thinking to myself that nature surely must have something else in mind for me on this inaugural trip to the Tetons. Consulting a park map as I drove, I tried to visualize the lay of the landscape concealed by the fog and passing snow flurries. I reached in my bag sitting next to me, looking for some musical accompaniment. Grabbing my Four Seasons CD, I selected the winter concerto, hoping that somehow Vivaldi might inspire the mood.

With the clutter of my thoughts gradually yielding to the music, I began to focus my attention on the groves of quaking aspens that lined the park road and patterned the hillsides, revealing themselves intermittently in the soft, eerie sunlight veiled by the quietly falling snow. As I photographed, the deliberate, staccato eighth notes of the strings and rapid flourishes of the solo violin created an embracing unity of my visual-musical encounter with this serene yet mysterious landscape. Photographing on through the day, I wondered what visual and life experiences inspired Vivaldi's musical expression of the four seasons. Although there was a considerable time and space separation between my experience and the life of Antonio Vivaldi, the genius and influence of his creative expression have endured the test of time.

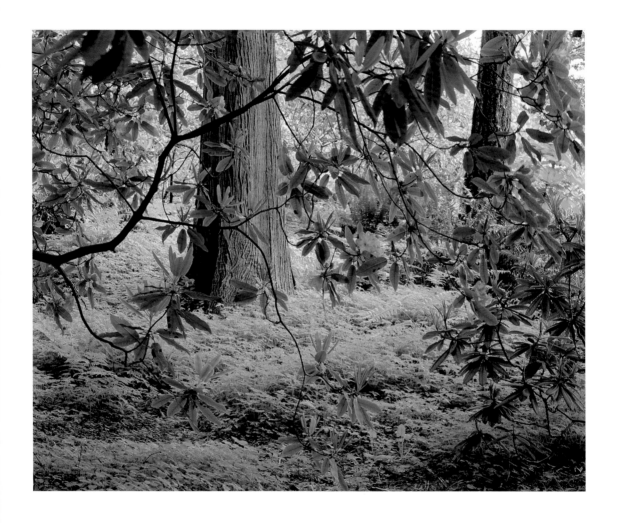

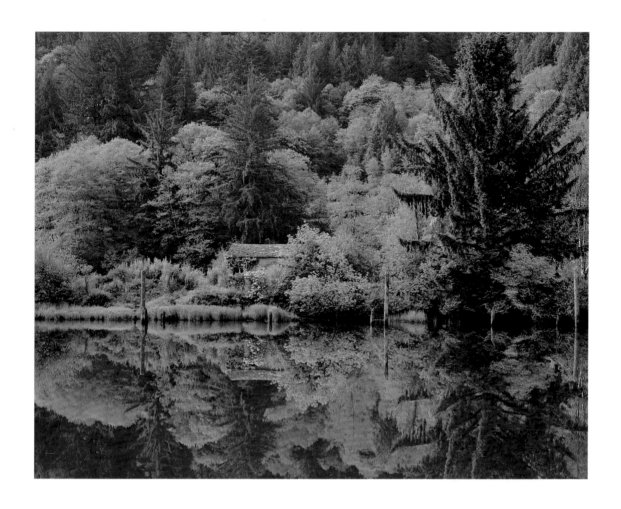

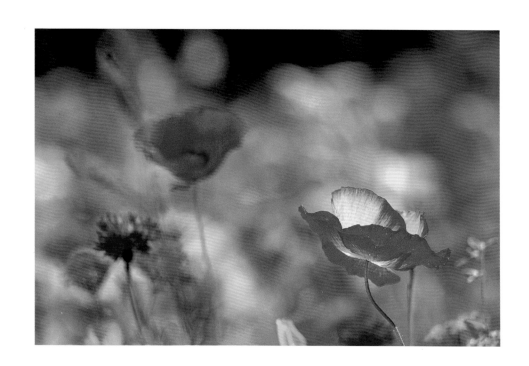

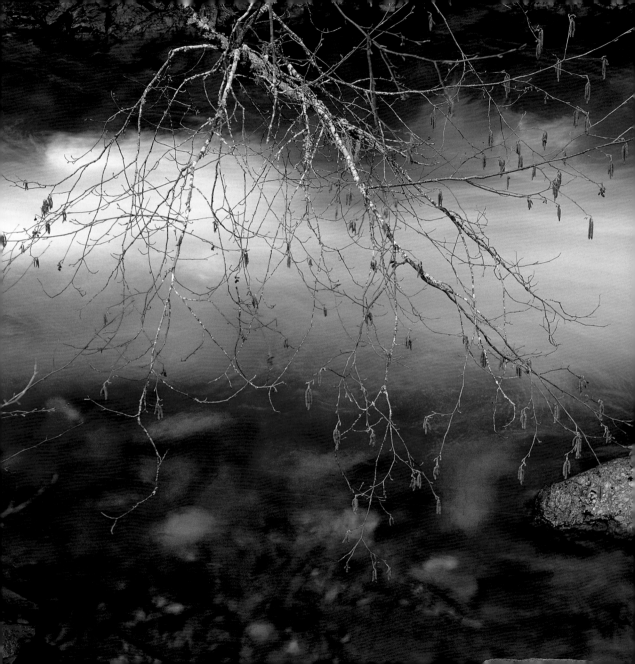

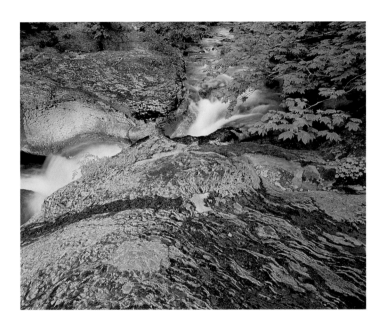

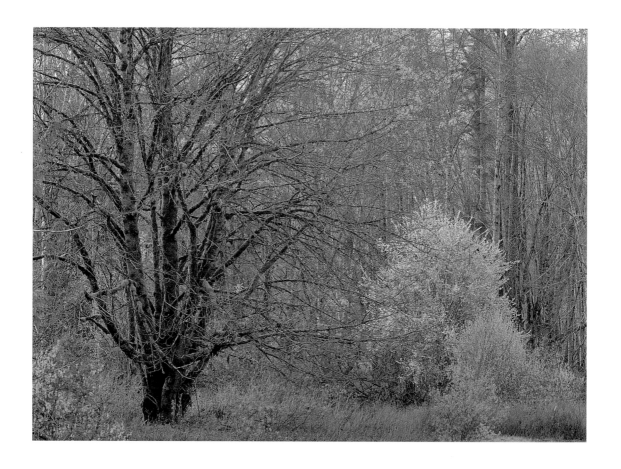

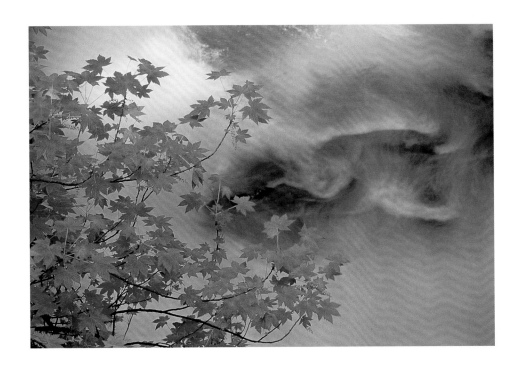

summer

I will be the gladdest thing
Under the sun!

I will touch a hundred flowers
And not pick one.

I will look at cliffs and clouds
With quiet eyes,

Watch the wind bow down the grass,
And the grass rise.

And when lights begin to show
Up from the town,

I will mark which must be mine,
And then start down!

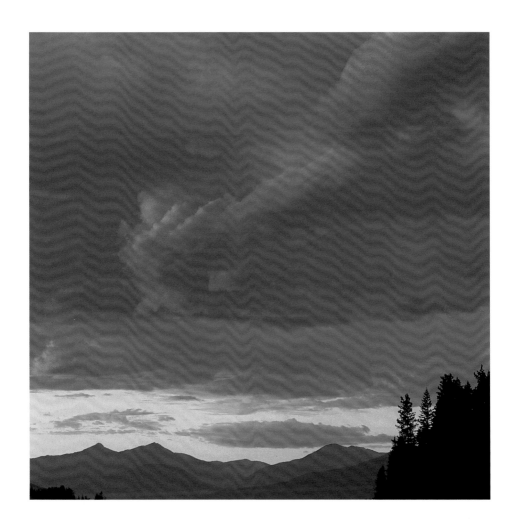

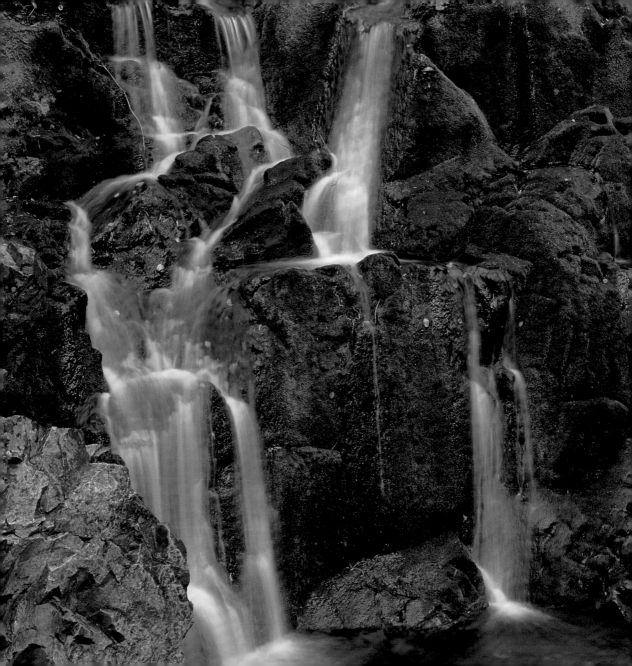

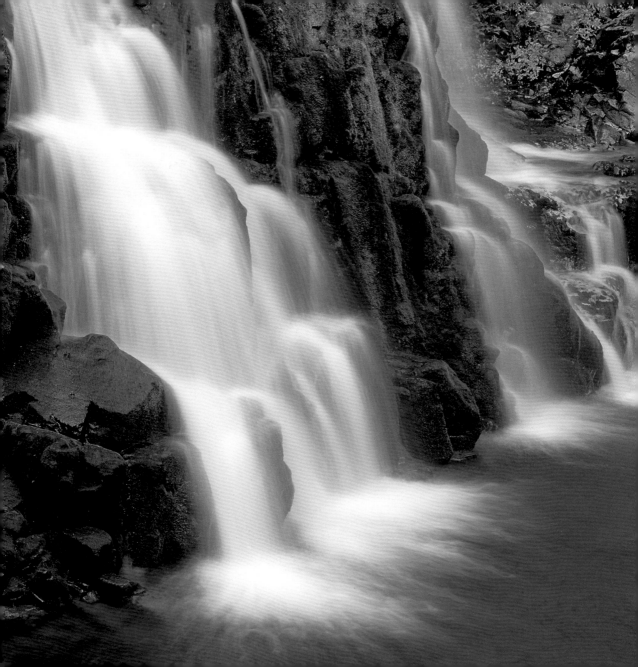

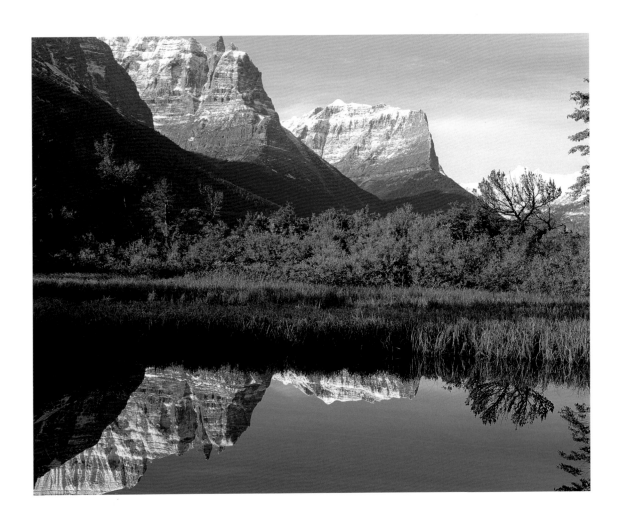

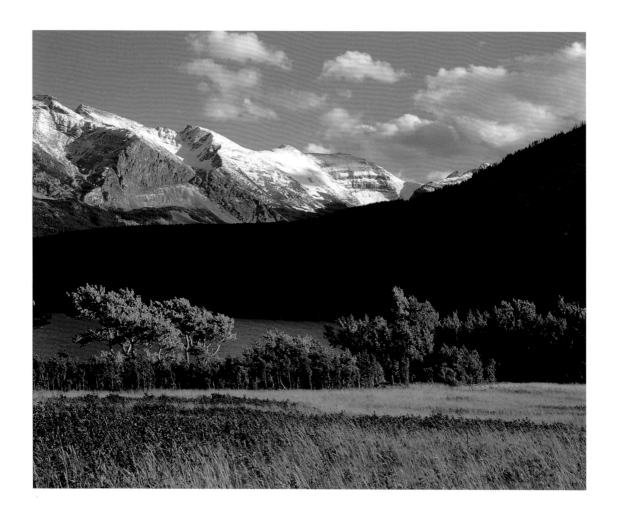

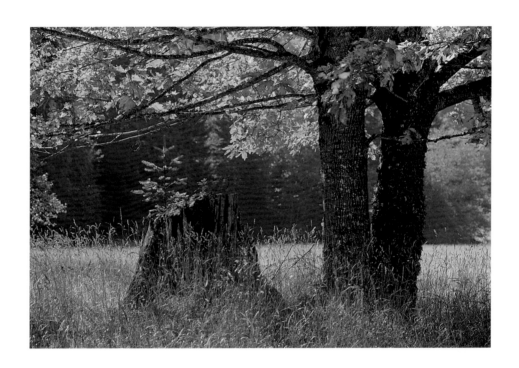

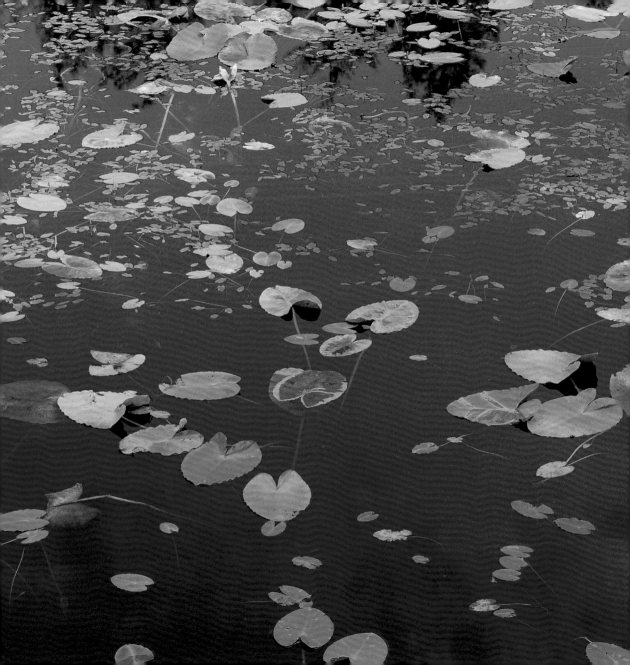

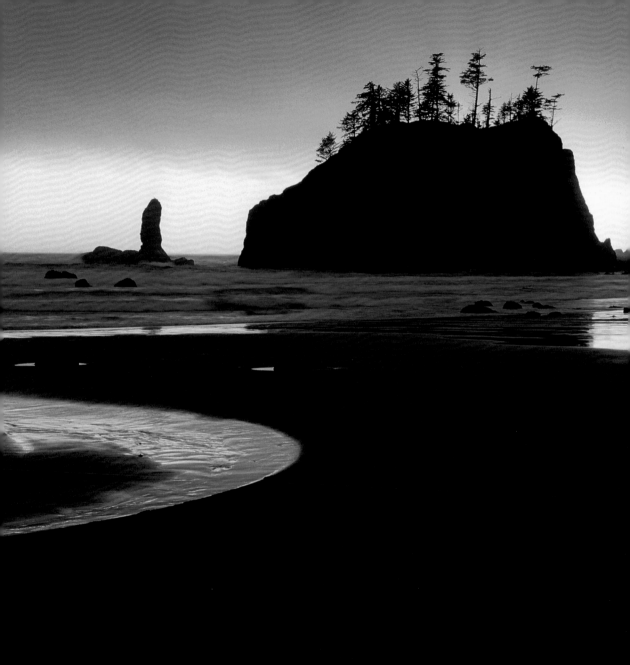

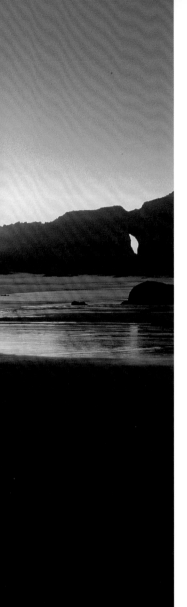

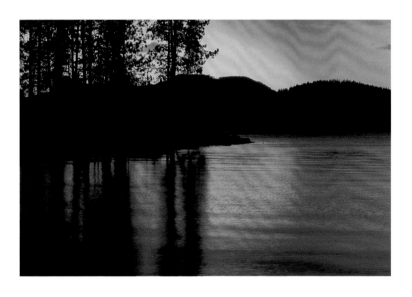

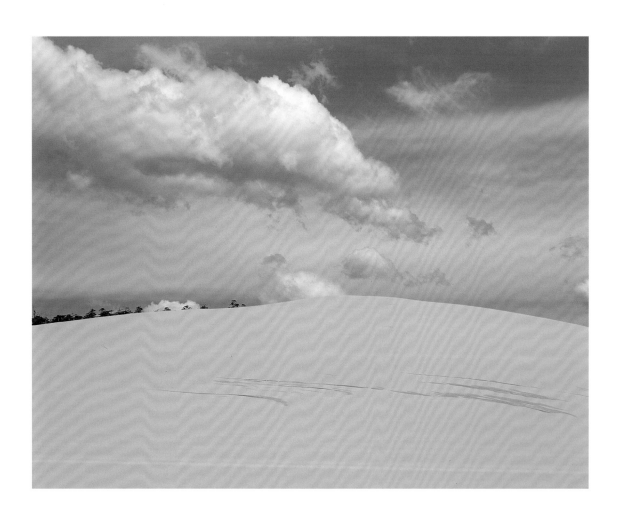

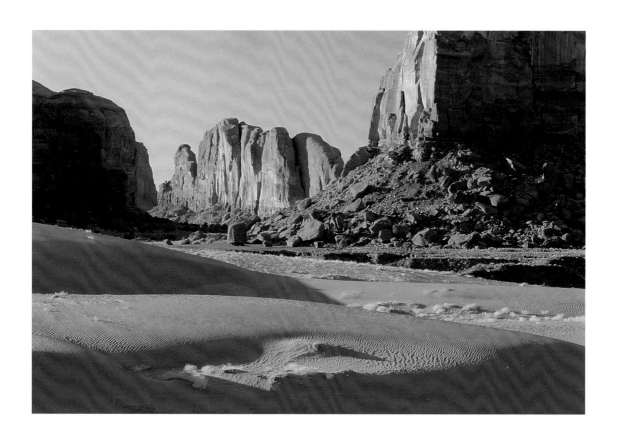

autumn

Ere, in the northern gale,
The summer tresses of the trees are gone,
The woods of Autumn, all around our vale,
Have put their glory on.

The mountains that infold
In their wide sweep, the colored landscape round,
Seem groups of giant kings, in purple and gold,
That guard the enchanted ground.

I roam the woods that crown
The upland, where the mingled splendors glow,
Where the gay company of trees look down
On the green fields below.

My steps are not alone
In these bright walks; the sweet southwest, at play,
Flies rustling, where the painted leaves are strown
Along the winding way.

And far in heaven, the while,
The sun, that sends that gale to wander here,
Pours out on the fair earth his quiet smile,—
The sweetest of the year.

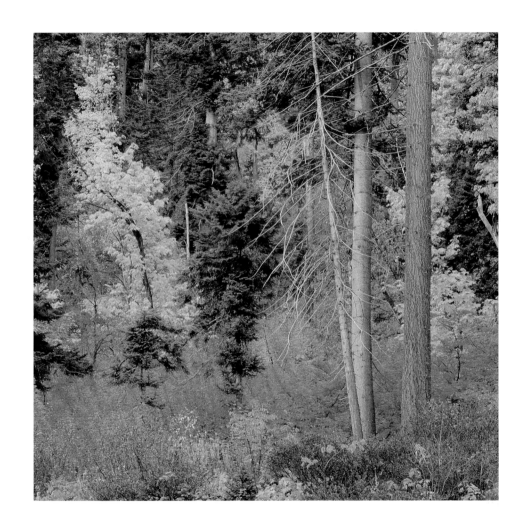

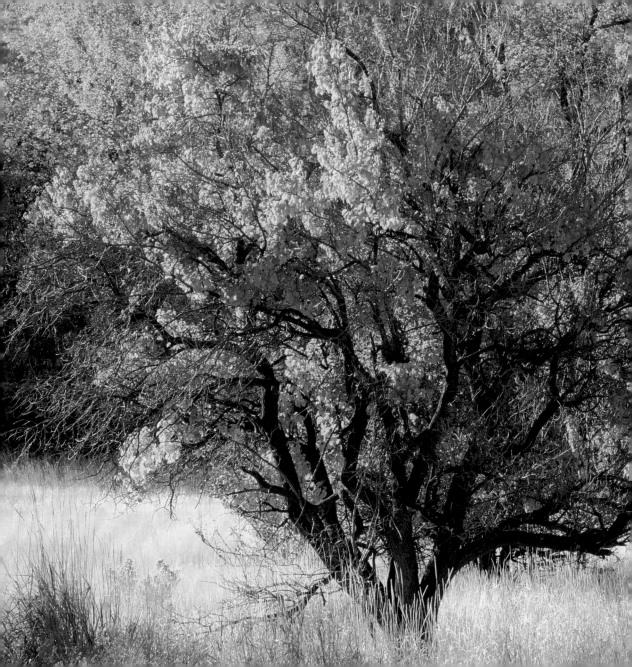

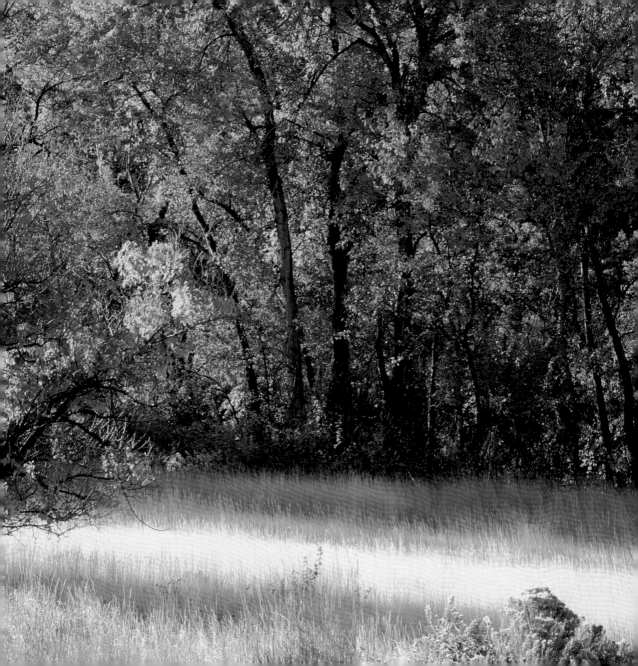

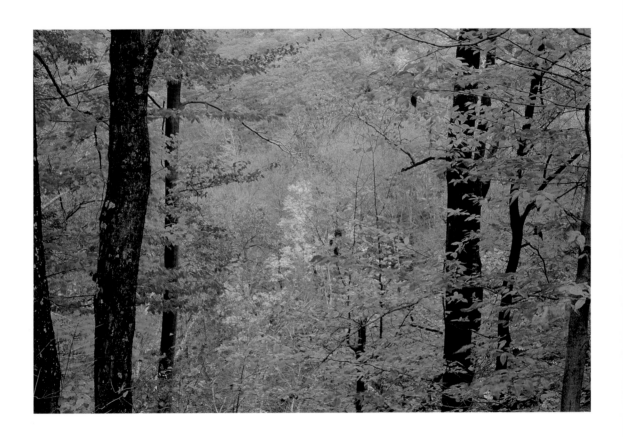

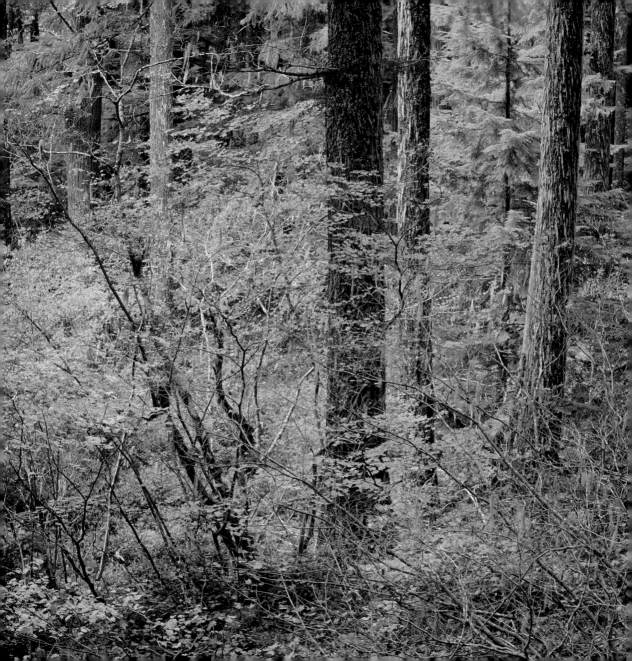

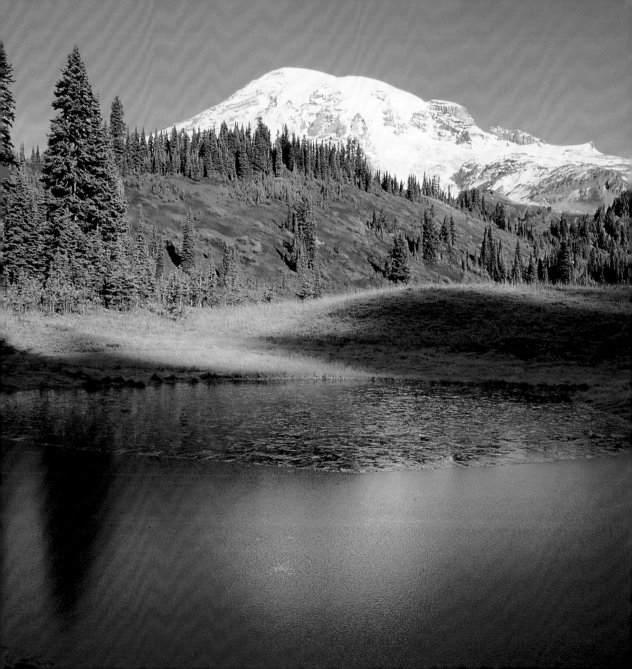

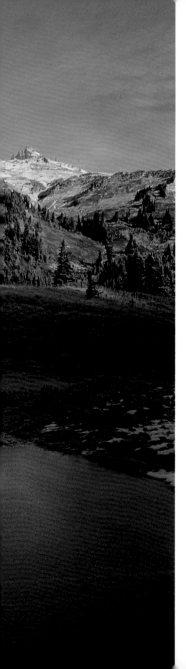

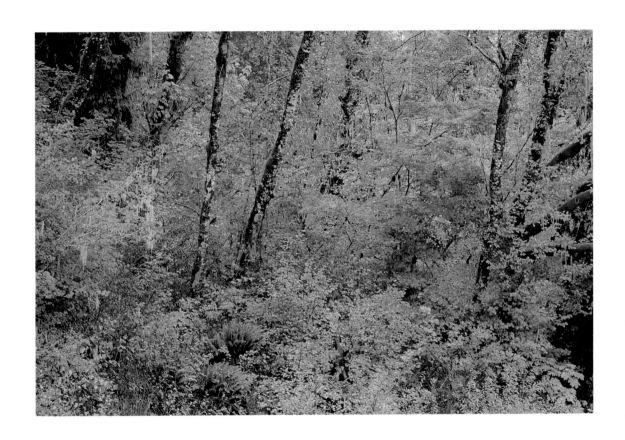

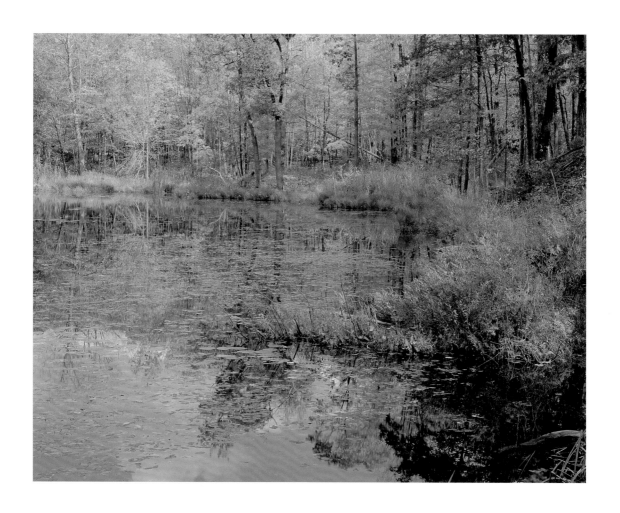

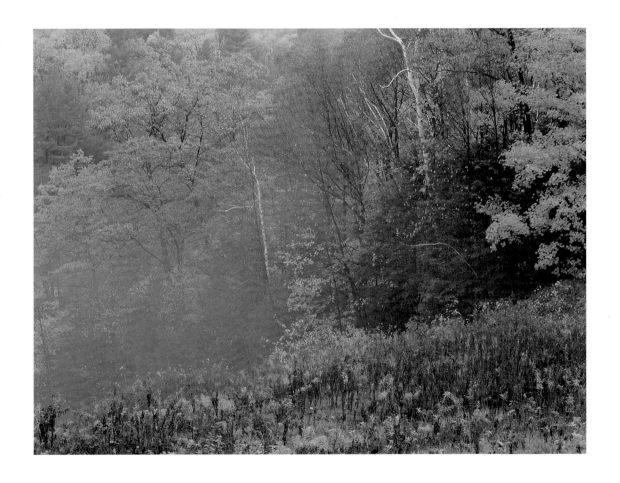

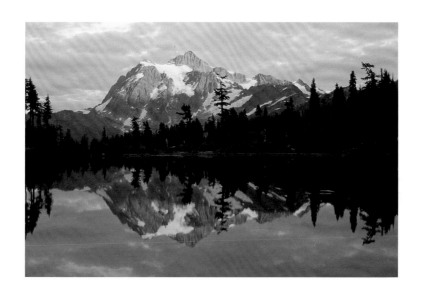

winter

Whose woods these are I think I know
His house is in the village though;
He will not see me stopping here
To watch his woods fill up with snow.

My little horse must think it queer
To stop without a farmhouse near
Between the woods and frozen lake
The darkest evening of the year.

He gives his harness bells a shake
To ask if there is some mistake.
The only other sound's the sweep
Of easy wind and downy flake.

The woods are lovely, dark and deep.
'But I have promises to keep,
And miles to go before I sleep,
And miles to go before I sleep.

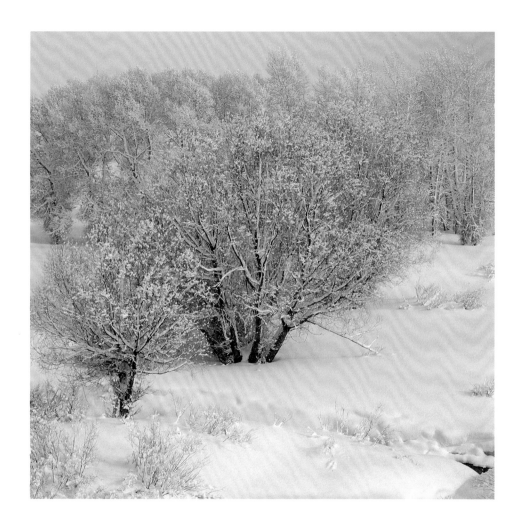

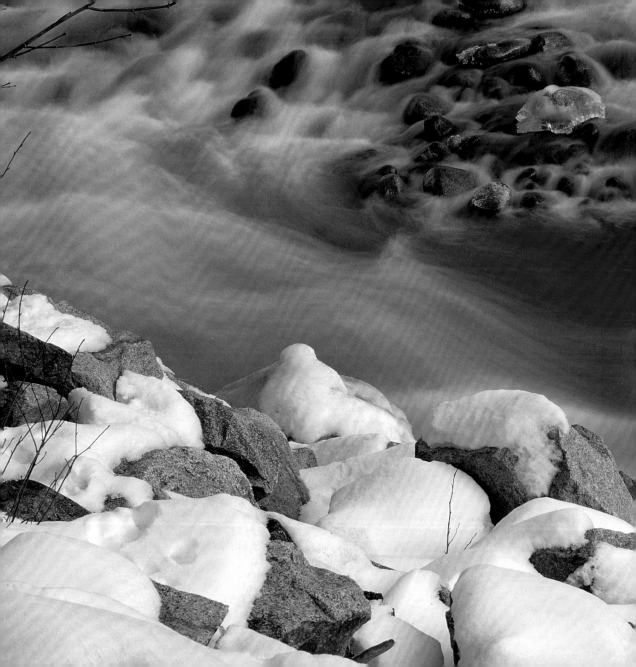

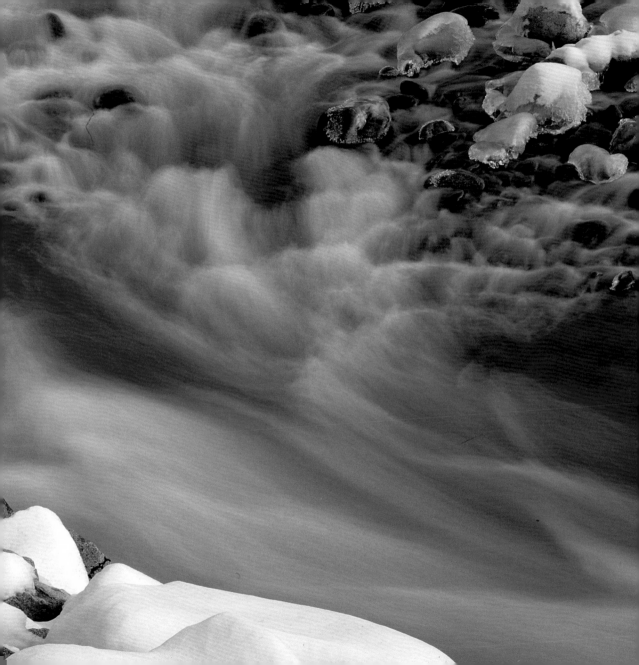

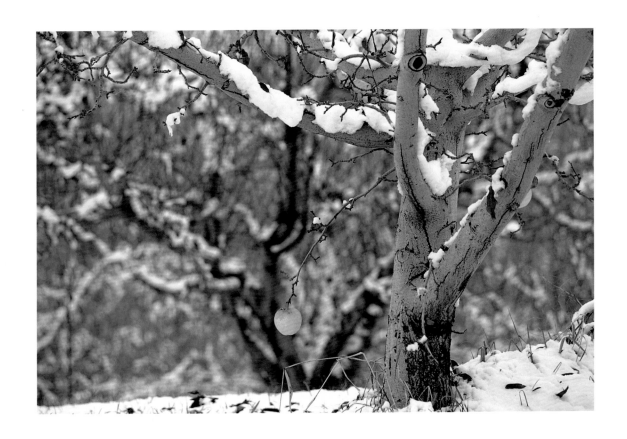

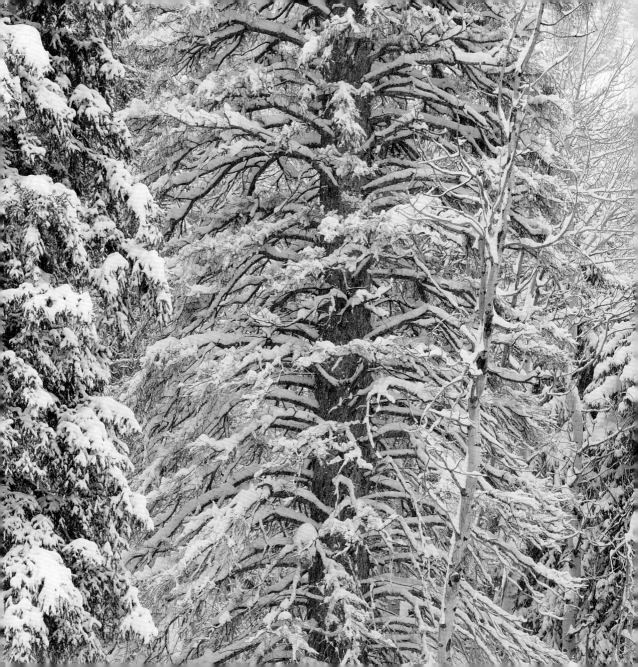

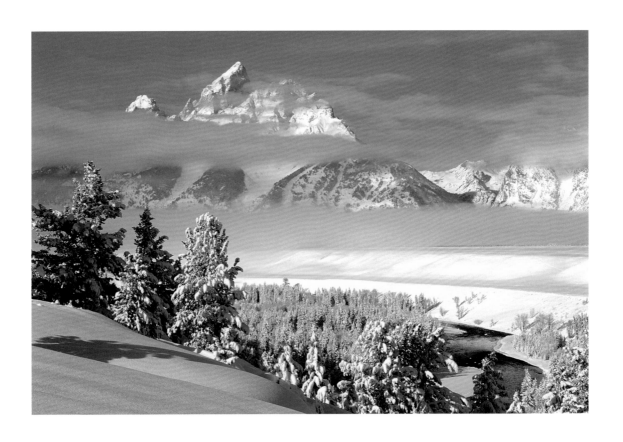

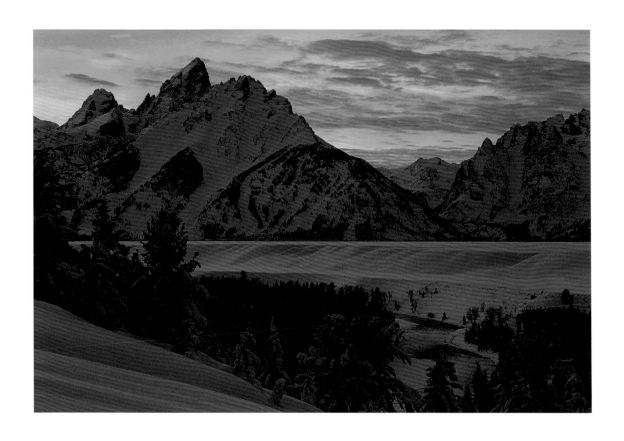

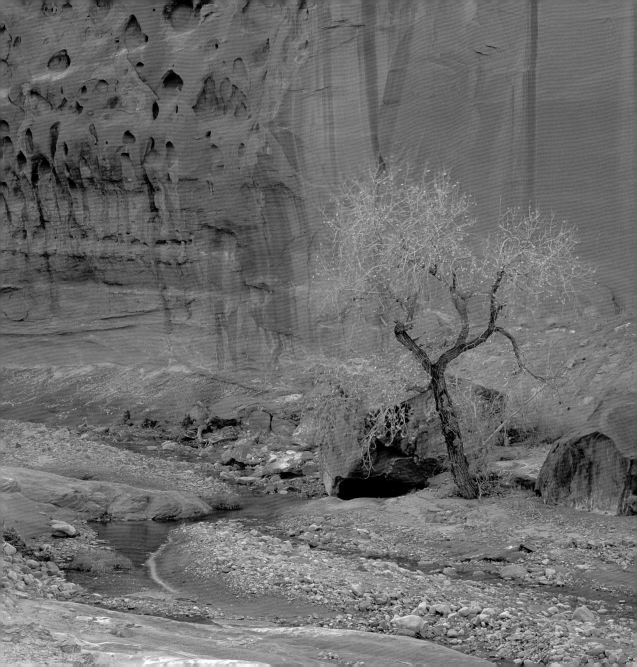

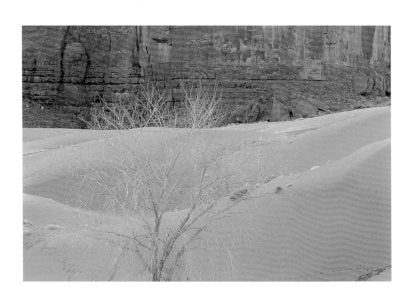

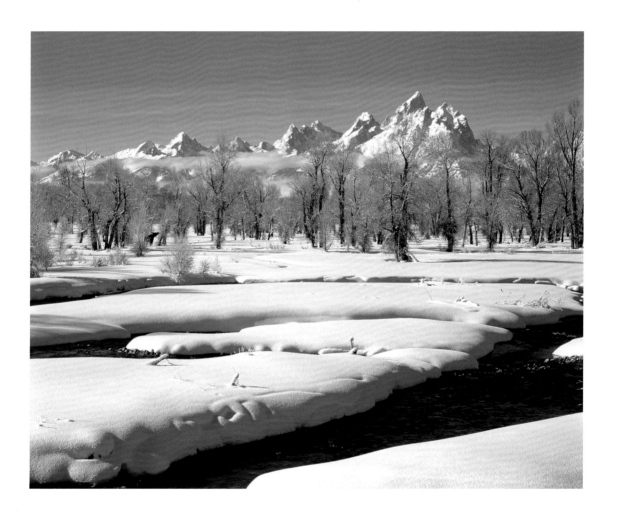

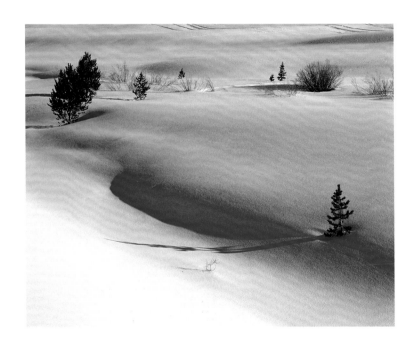

photographic plates

page

inset Sauk River, Washington, Pentax 67, 135mm macro lens, 1/2 sec., F/32

7 Washington Park Arboretum, Seattle, Washington, Pentax 67, 135mm macro lens, 1/8th sec., F/22

9 Palouse Hills, Washington, Nikkor 75-300mm zoom lens, 1/15th sec., F/22

10-11 Soleduck River, Washington, Nikkor 75-300mm zoom lens, 1/8th sec., F/8

12 Daisies and Lupine, Washington, Pentax 67, 135mm macro lens, 1/15th sec., F/22

13 Wild Rhododendrons, Washington, Pentax 67, 135mm macro lens, 1/4th sec., F/32

14 Suislaw River, Oregon, Pentax 67, 200mm lens, 1/15th sec., F/22

15 Poppies, Washington, Nikkor 75-300mm zoom lens and extension tube, 1/60 sec., F/5.6

16 Skate Creek, Washington, Pentax 67, 135mm macro lens, 1/4th sec., F/32

17 Cedar Creek, Opal Creek Watershed, Oregon, Pentax 67, 45mm lens, 1/4th sec., F/22

18 Elwa River Valley, Washington, Pentax 67, 200mm lens, 1/8th sec., F/32

19 Soleduck River, Washington, Nikkor 75-300mm zoom lens, 1/60th sec., F5.6

21 Priest Lake, Idaho, Nikkor 75-300mm zoom lens, 1/2 sec., F/16

22-23 Opal Creek Preserve, Oregon, Pentax 67, 135mm macro lens, 1/4th sec., F/32

24 Glacier National Park, Montana, Pentax 67, 135mm macro lens, 1/15th sec., F/32

25 Glacier National Park, Montana, Pentax 67, 135mm macro lens, 1/5th sec., F/22

26 Elwa River Valley, Washington, Nikkor 75-300mm zoom lens, 1/60th sec., F/11

27 Orcas Island, Washington, Pentax 67, 135mm macro lens, 1/4th sec., F/32

28 LaPush Beach Two, Washington, Nikkor 75-300mm zoom lens, 1/4th sec., F/16

29 Priest Lake, Idaho, Nikkor 75-300mm zoom lens, 1/4th sec., F/22

30 Dunes Recreational Area, Oregon, Pentax 67, 200mm lens, 1/60th sec., F/22

31	Monument Valley, Arizona, Nikkor 75-300mm zoom lens, 1/15th sec., F/22
33	Steven's Pass, Washington, Pentax 67, 135mm macro lens, 1/8th sec., F/22
34-35	Oak Creek Canyon, Washington, Pentax 67, 135mm macro lens, 1/15th sec., F/32
36	Mt. Washington, Massachusetts, Pentax 67, 135mm macro lens, 1/8th sec., F/32
37	Mt. Rainier National Park, Washington, Pentax 67, 200mm lens, 1/4th sec., F/32
38	Mt. Rainier National Park, Washington, Nikkor 24-50mm zoom lens, 1/8th sec., F/22
39	Stillaquamish River, Washington, Nikkor 75-300mm zoom lens, 1/15th sec., F/16
40	Stillaquamish River, Washington, Nikkor 75-300mm zoom lens, 1/4th sec., F/22
41	Pond in Upstate New York, Pentax 67, 135mm macro lens, 1/4th sec., F/32
42	Lenox, Massachusetts, Pentax 67, 135mm macro lens, 1/2 sec., F/32
43	Mt. Shuksan, Washington, Nikkor 24-50mm zoom lens, 1 second, F/22
45	Grand Teton National Park, Pentax 67, 135mm macro lens, 1/4th sec., F/32
46-47	Index River, Washington, Pentax 67, 135mm macro lens, 1/2 second, F/32
48	Wenatchee, Washington, Nikkor 75-300mm zoom lens, 1/4th sec., F/8
49	Sawtooth Mountains, Idaho, Pentax 67, 200mm lens, 1/4th sec., F/22
50	Grand Teton National Park, Wyoming, Pentax 67, 135mm macro lens, 1/30th sec., F/22
51	Grand Teton National Park, Wyoming, Pentax 67 135mm macro lens, 1 second, F/22
52	Glen Canyon Recreation Area, Utah, Pentax 67, 200mm lens, 1/2 second, F/22
53	Monument Valley, Arizona, Nikkor 75-300mm zoom lens, 1/4th sec., F/32
54	Grand Teton National Park, Wyoming, Pentax 67, 135mm macro lens, 1/30th sec., F/22
55	Stanley, Idaho, Pentax 67, 200mm lens, 1/15th second, F/22

All photographs in this book were taken with Fuji Velvia film except plates 28 and 48 which were Kodachrome 25.

soundtrack notes

41:00 | **La Primavera (Spring) (9:36)**

Concerto N. 1 in E Major

I. Allegro (3:23)

II. Largo (2:19)

III. Allegro (3:56)

L'Estate (Summer) (11:44)

Concerto N. 2 in G Minor

I. Allegro non molto (5:32)

II. Adagio (2:22)

III. Presto (2:40)

L'Autunno (Autumn) (11:04)

Concerto No. 3 in F Major

I. Allegro (5:03)

II. Adagio molto (2:32)

III. Allegro (3:15)

L'Inverno (Winter) (8:36)

Concerto No. 4 in F Minor

I. Allegro non molto (3:18)

II. Largo (2:00)

III. Allegro (3:04)

Cambridge Chamber Orchestra

Rolf Smedvig	music director, conductor
Emanuel Borok	violin soloist*
Cecylia Arzewski	violin*
Bo Youp Hwang	violin*
Gottfried Wilfinger	violin*
Leo Panasevich	violin*
Darlene Gray	violin*
Marylou Speaker	violin*
Vyacheslav Uritsky	violin*
Ronald Knudsen	violin*
Ronan Lefkowitz	violin*
Burton Fine	viola*
Michael Zaretsky	viola*
Bernard Kadinoff	viola*
Jules Eskin	cello*
Ronald Feldman	cello*
Jonathan Miller	cello*
Edwin Barker	bass*
Joyce Lindorff	harpsichord

*members of the Boston Symphony Orchestra

Emanuel Borok, violin, was born in Russia in 1944. He received his early musical education at the Darzinja Music School in Riga. In 1969 he graduated from the Institute and joined the Orchestra of the Bolshoi Theater. In 1973 Emanuel Borok left Russia in order to emigrate to Israel, where he accepted a position as concertmaster of the Israel Chamber Orchestra. Mr. Borok has served as assistant concertmaster of the Boston Symphony and is currently the Concertmaster of the Dallas Symphony Orchestra.